www.hexagonbook.com

Love Letter
SON IL

2022년 4월 30일 초판 1쇄 발행

지은이 손　일
발행인 조동욱
편집인 조기수
펴낸곳 헥사곤 Hexagon Publishing Co.
등　록 제 2018-000011호 (2010. 7. 13)
주　소 경기도 성남시 분당구 성남대로 51, 270
전　화 070-7743-8000
팩　스 0303-3444-0089
이메일 joy@hexagonbook.com
웹사이트 www.hexagonbook.com

ⓒ 손　일 2022 Printed in Seoul, KOREA

ISBN 979-11-89688-82-0 04650
ISBN 979-11-89688-81-3 (세트)

SON IL
Love Letter

www.hexagonbook.com
Korea 2022

작가 손 일
〈물성과 행위를 통한 사유〉

정종효 (부산시립미술관 학예연구실장)

현대미술에 있어 물성과 행위는 작가의 조형어휘를 확장하는 수단으로 작용한다. 3차원의 환영을 평면으로 표현하는 단순한 방식은 페인팅 기법에 의지해 온 회화에서 그 한계성을 보였고, 새로운 표현에 대한 변화를 요구했다. 이에 부응하듯 평면성의 본질에서 벗어나지 못한 회화는 아방가르드라는 새로운 미술사조의 탄생으로 현대미술에 진입하면서 표현 방식을 확장해왔다. 특히 아방가르드는 물성에 대한 인식 전환에 큰 영향을 끼침으로써 미술 장르의 벽을 허무는 계기가 되었다. 역으로, 입체적인 오브제를 평면화시키는 작업 또한 현대미술 기법의 확장성을 보여주는 한 단면이다. 현대미술은 조형적 관점에서 오브제의 물성이 가지고 있는 가능성을 발견하고 조형언어의 수단이자 사유의 확장을 위한 새로운 기법으로 보편적 개념으로 활용하고 있다. 반복되는 행위를 통해 나타나는 오브제의 조형적 구조는 단순한 형태 또는 색에 대한 시각적 판단만으로 접근하지 않는다. 행위는 작가의 작업으로 인식되고 정체성을 부여하는 무형의 조형언어로 등장한다.

프랑스의 미술사학자 앙리 포시옹(Henri Focilon)은 그가 쓴 책에서 물질의 조형적 성질에 대해 다음과 같이 이야기하고 있는데 물성에 대한 개념의 중요성을 일축한다고 볼 수 있다.

> "물질은 형태이다. 그리고 그 점을 통해 물질은 미술에서 형태들의 생을 불러내 발전시킨다. 그리하여 물질의 형태는 또 다른 형태를 낳고 암시하고 증식시킨다. 미술의 형태에 그토록 까다롭게 구는 이 물질은 미술의 형태에 일종의 매력으로 작용하고, 역으로 물질은 미술의 형태에 의해 심도 있게 변모하기 때문이다."〈재인용〉

손일이 사용하는 주요 재료에서 볼 수 있는 물성은 한지의 원료인 닥섬유와 최근의 작업에 도입하게 된 폴리재질의 민세사에 의해 크게 두 가지 성향으로 나타난다. 재료의 물성과 반복적 집적accumulation 행위가 발현되는 탐색을 이어가고 있다. 이 두 가

Artist SON IL
‹Reasoning through Materiality and Action›

Cheong Jonghyo (Chief curator, Busan Museum of Art)

In the contemporary art, materiality and action serve as means of expanding an artist's figurative vocabulary. A simple way of expressing three-dimensional visions in a flat plane has revealed its limitations in painting in the genre of painting where painting techniques have prevailed, and has demanded changes to new modes of expression. In this sense, painting which has not escaped from the nature of flatness, has expanded its modes of expression by tapping onto the contemporary art with the birth of a new "avant-garde" art trend. In particular, the avant-gardeness has had a great influence on the change of perception of materiality, which triggered breaking down the walls of art genres. On the other hand, planarizing three-dimensional objects also hints at the scalability of materiality in objects in the figurative point of view. Contemporary art has been as a universal concept as a new technique to expand the scope of reasoning as well as a means of figurative language, while discovering the possibility of the physical or material nature of objects from a figurative point of view. The figurative structure of objects that appears through repeated actions does not approach only with visual judgments of simple shapes or colors. Actions appear as an intangible figurative language that is recognized as the work of an artist and gives identity.

French art historian Henri Focillon talks about the figurative traits of materials in his book as follows, dismissing the importance of the concept of materiality:

> "Materials are a form. Materials invoke and develop the life of forms in art through that. Thus, the form of materials gives rise to, implies and multiplies another form. This material, which is so particular about the art form, acts as a kind of attraction to the art form, and conversely, materials are transformed in depth by the art form." (re-quoted)

The materiality seen in the main materials used by Son Il appear in two main flows: mulberry fiber, a raw material for hanji, the Korean traditional paper, and polyester threads recently applied to his recent works. His artistic search has been going on where materials' physical properties and repetitive accumulation are reproduced. Regardless of

지 중 어느 재료를 사용하든 동일하거나 획일적인 반복 행위가 아닌 2차원적 여백 혹은 3차원적 공간을 재현하는 독창적인 작업이어 나가고 있어 그 의미를 평가할 수 있다. 이러한 경향은 다분히 한국의 미적 철학을 반영하는 작업으로도 해석할 수 있다. 한글의 초판의 자모를 이용한 활자, 작업의 주된 재료로 사용되는 한지의 원료인 닥섬유 그리고 실, 화면에서 나타내는 여백 등은 동양적이고 한국적인 의식을 현대적인 감각으로 완성된 작품임을 여실히 보여준다. 특히 작가가 주요 소재로 사용하고 있는 한글 자모는 현재의 작업을 태동하게 한 근원이다. 목판에서 생겨난 한글 초판 훈민정음의 인쇄본에서 도입한 한글의 형상은 실 또는 닥섬유를 이용한 작가의 반복과 차이의 행위를 통해 훈민정음과는 또 다른 메시지를 전달한다. 닥섬유를 이용한 작업의 반복적 행위는 입체화된 한글 자모 위에 겹겹이 쌓는 행위로 완성되지만 전체를 가득 채워 밀봉하지 않는다. 닥섬유의 결과 결 사이에 틈들은 그 아래에 오랜 시간 침전되어 있는 듯한 자모들이 외부 공기 또는 공간과의 통풍 작용으로 마치 세상과 소통할 수 있어 생명을 유지할 수 있다. 한국의 전통 한지가 가지고 있는 특성을 살린 독자적인 조형언어를 발현하고 있다.

손일의 작업에서 주된 재료인 닥섬유는 민세사라는 새로운 재료를 이용해 최근의 작업으로 이어진다. 행위의 집요함은 실을 집적하는 과정에서 더욱더 끈질기게 반영된다. 반복의 행위는 입체화된 한글초성의 단순한 구조 위에 차이를 지닌 공간으로 표현된다. 작품에서 나타나는 여백 혹은 공간의 여유로운 은유법은 실을 사용한 작업에서도 변함없이 나타나고 있다. 물성과 행위는 집적되고 합쳐지는 단순함이 아닌 공간 또는 여백으로써 시각적 정신적 의미를 내포하고 있다. 기존의 닥섬유와 달리 실이라는 물성의 차이에서 나타나는 변화된 작품의 성향은 매력적인 컬러감이다. 닥섬유의 물성을 이용해 단색의 단조로움의 미감을 이어왔다면 실을 용한 작품은 다양한 색과 글라데이션으로 변모하였다. 물성과 행위의 반복을 기저로 스펙트럼과 같은 다양성과 확장성을 과시한다. 작가가 선택한 물성과 행위의 반복과 차이는 자기 수행으로 이어지고 정체성으로 표출된다.

which of these two materials is used, the meaning of the original work of reproducing two-dimensional margins or three-dimensional spaces, not the same or consistent repetition, can be evaluated. This tendency can be interpreted as his approach in reflecting the aesthetic philosophy in Korea.

The letter types using consonants and vowels of the first edition of hangul or the Korean alphabet, mulberry fiber as the ingredient for hanji as the main material for his work, and threads, and some empty space on the pictorial plane clearly show that Oriental and Korean mindset has been integrated with a modern sense in the work. In particular, the Korean alphabet as the main subject matter is the source of his current work. The shape of hangul, which was introduced in the first printed version of Hunminjeongeum (i.e., The Correct/Proper Sounds for the Instruction of the People, which is a document describing an entirely new and native script for the Korean language) in his work delivers a different message from the original one through his repetitive and different act using threads or mulberry fiber. His competitive action using mulberry fiber is completed by stacking layers on three-dimensional Korean letters, but it does not seal the entire letters by containing them all. The gaps between each layer of mulberry fiber can maintain life as the letters, which seem to be deposited for a long time under them, can communicate with the world through ventilation with external air or space. They express their own figurative language that utilizes the characteristics of hanji.

Mulberry fiber as the main material in Son Il's work has been used in his recent work with the usage a new material of polyester threads. The persistence of his actions is reflected more and more persistently in the process of accumulating threads. The act of repetition is expressed as a space with a difference on top of the simple structure of three-dimensional Korean initials. The leisurely metaphor of space or space that appears in his work remain unchanged even in his thread-based work. Materiality and action imply visual and psychological meanings as spaces or margins instead of the simplicity where materiality and actions are accumulated and integrated. While materiality of mulberry fiber has been used to carry on the aesthetic sense of simplicity in monochromes, his thread-based works have been modified through various colors and gradation. Based on the repetition of materiality and action, his work exudes the spectrum-like diversity and scalability. The repetition and difference of materiality and actions he opted for develop into self-control and are expressed as identity.

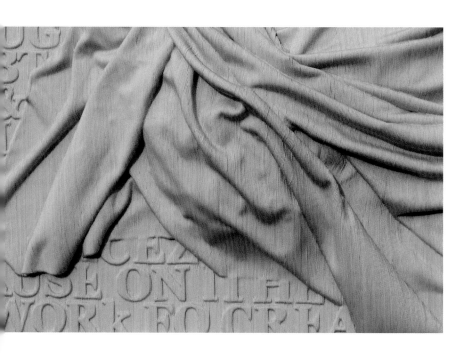

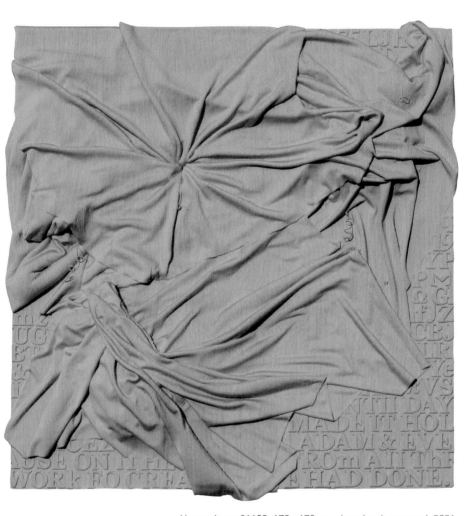

Unsent Letter21103 172×172 cm thread resin on panel 2021

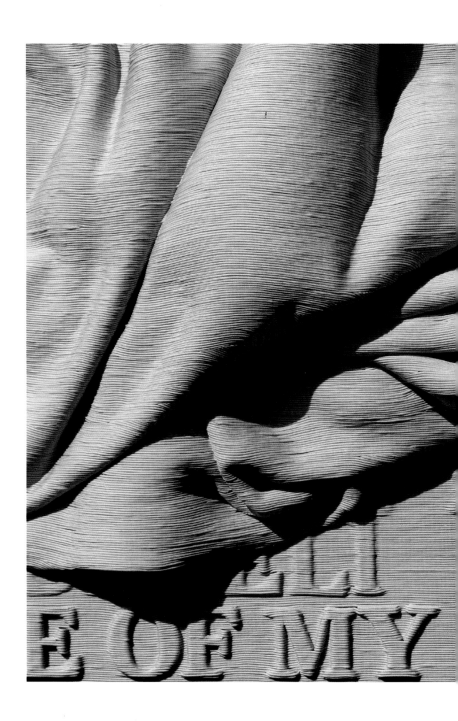

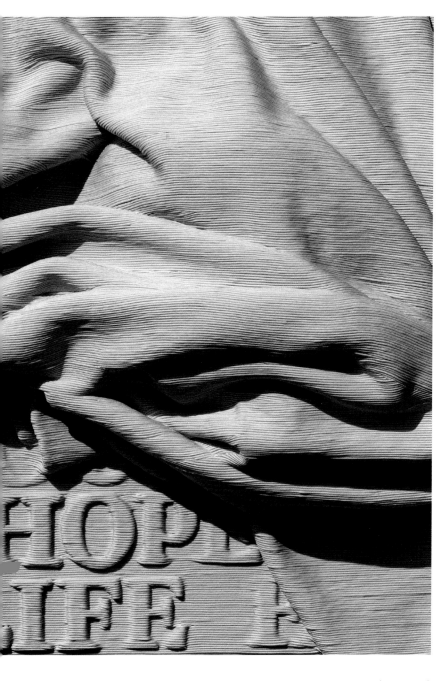

Unsent Letter21041 172×172cm thread resin on panel（detail view）

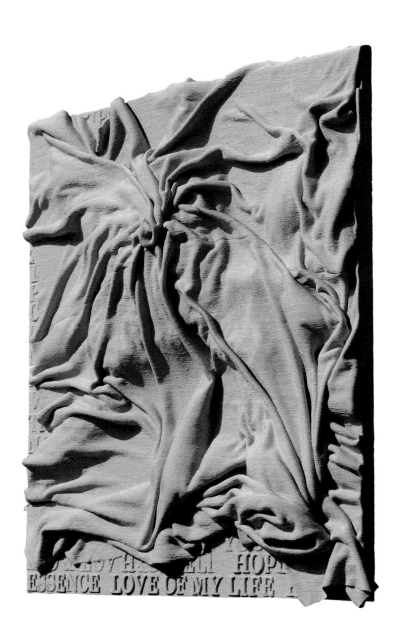

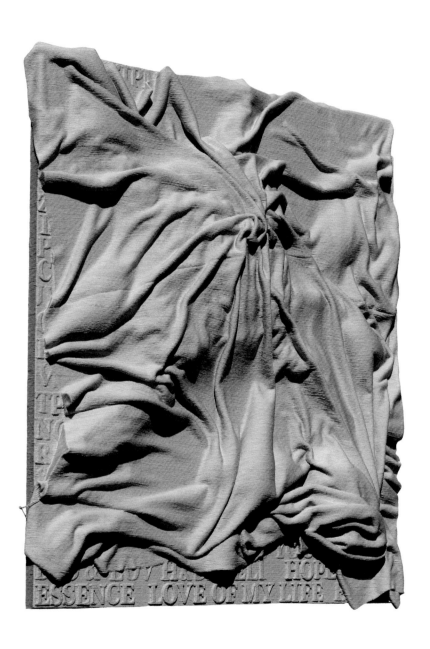

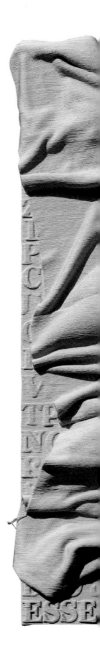

Unsent Letter21041 172×172cm thread resin on panel 2021

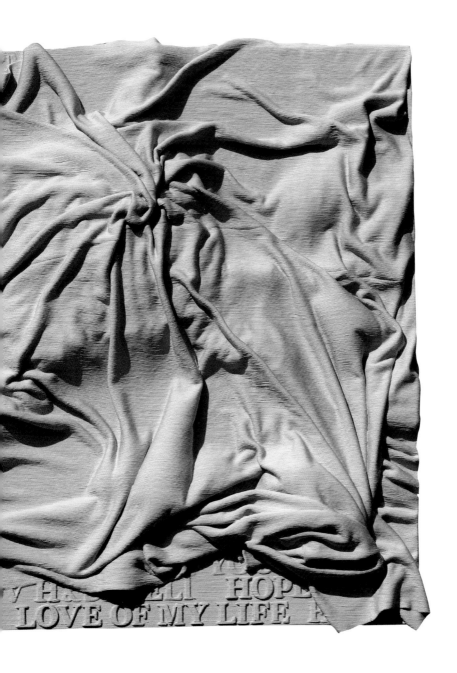

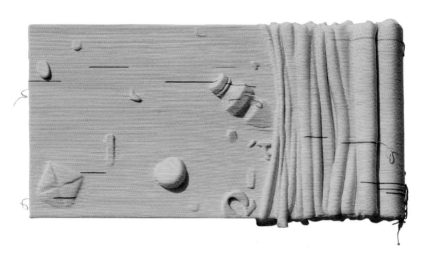

Unsent Letter22201
84×43cm
thread resin on panel
2022

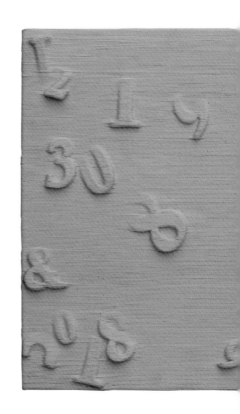

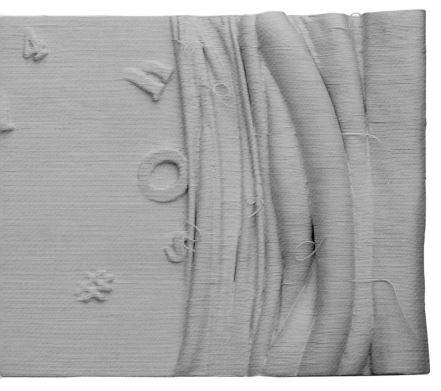

Unsent Letter22202 65×32cm thread resin on panel 2022

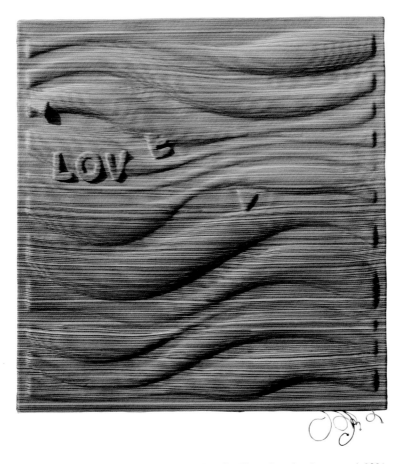

Love21125 50×53cm thread resin on panel 2021

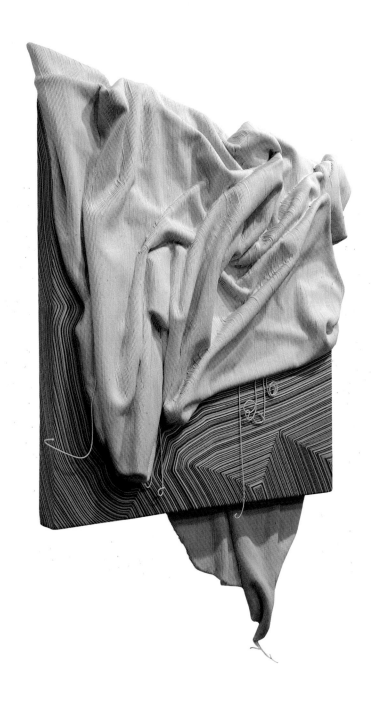

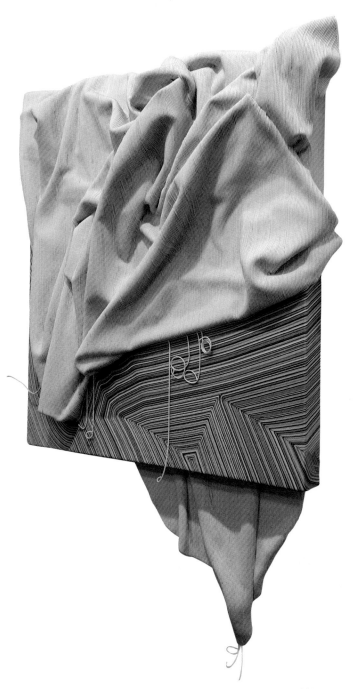

Love Letter21091 67×90cm thread resin on panel 2021

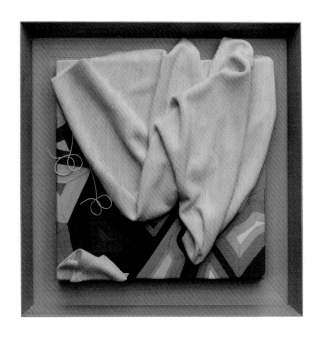

Love Letter21101 45×47cm thread resin on panel 2021

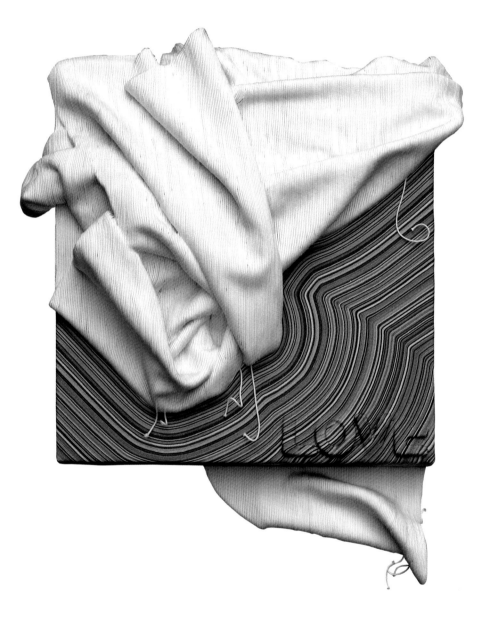

Love Letter21102 45×50 cm thread resin on panel 2021

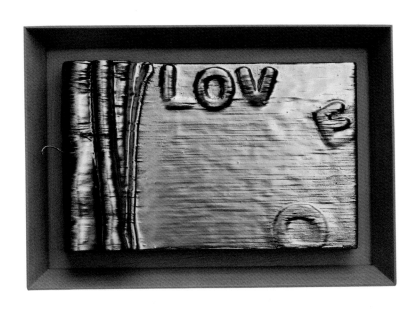

Love21801 27×15cm thread resin on panel 2021

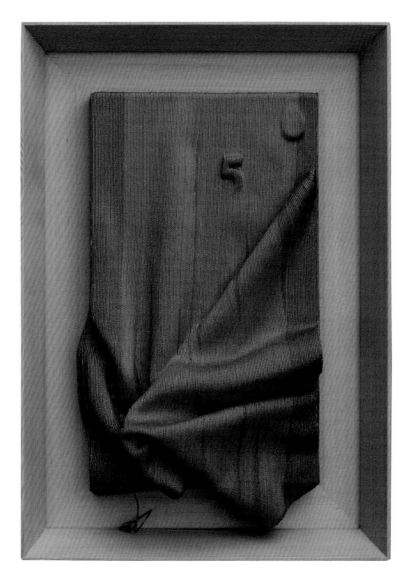

Love21802　17×30cm　thread resin on panel　2021

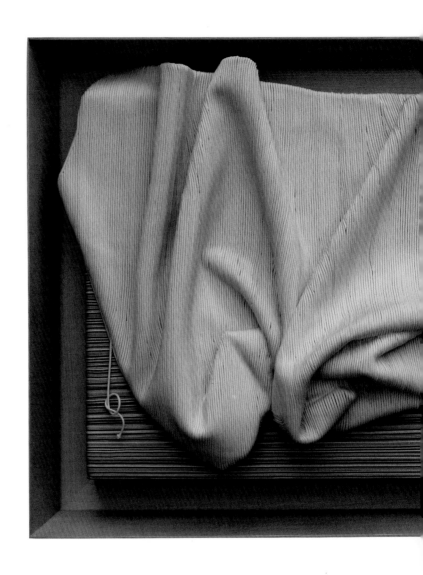

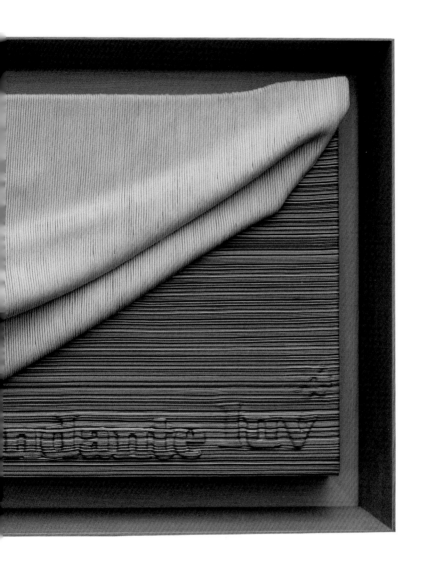

Love Letter21092 65×37cm thread resin on panel 2021

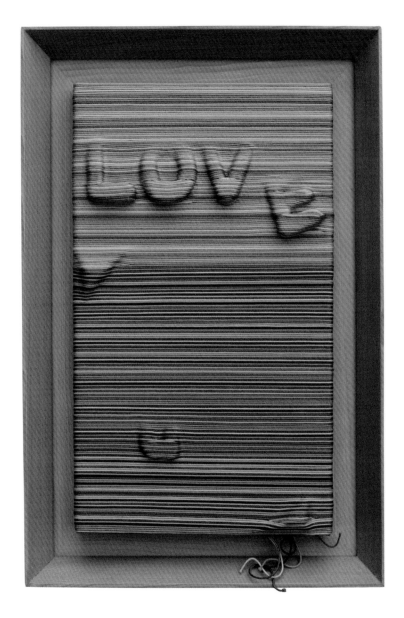

Love21803 15×28cm thread resin on panel 2021

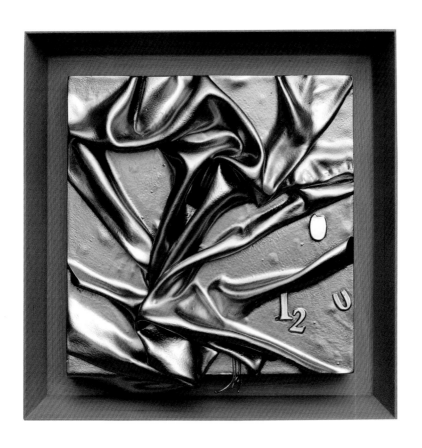

Love21804 30×33cm thread resin on panel 2021

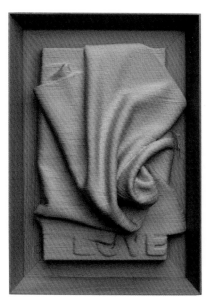 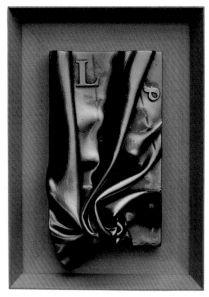

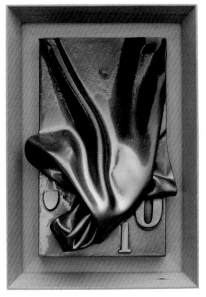
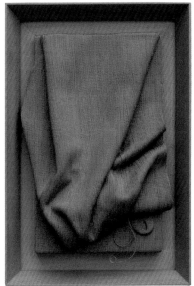

Love21805 18×26cm thread resin on panel 2021
Love21806 16×29cm thread resin on panel 2021
Love21807 18×25cm thread resin on panel 2021
Love21808 18×25cm thread resin on panel 2021

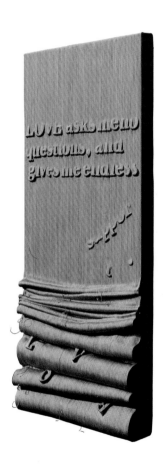

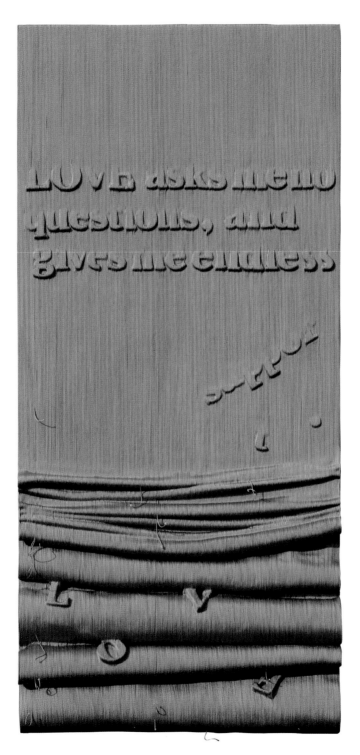

Love Letter21095 67×90cm thread resin on panel 2021

Love22031 34×69cm thread resin on panel 2022

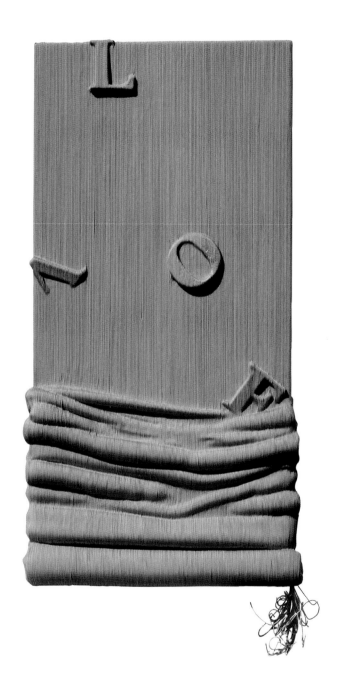

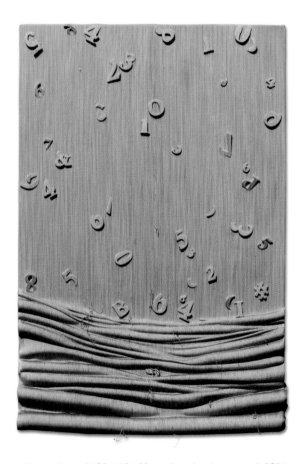

Unsent Letter2103 118×83cm thread resin on panel 2021

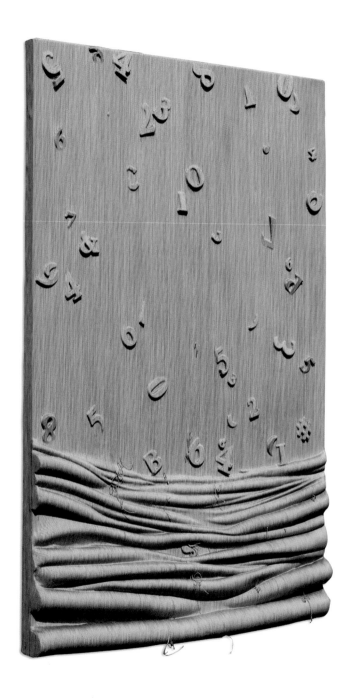

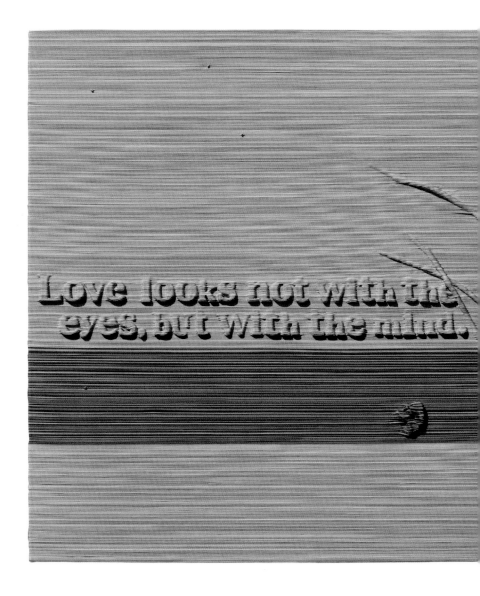

Love looks not with the eyes, but with the mind.

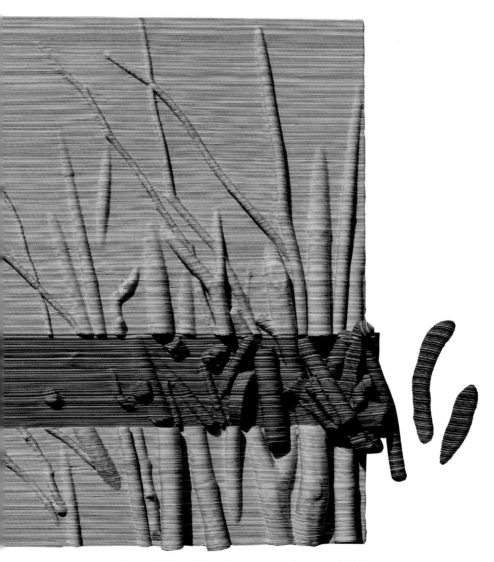

Unsent Letter210933 230×115cm thread resin on panel 2021

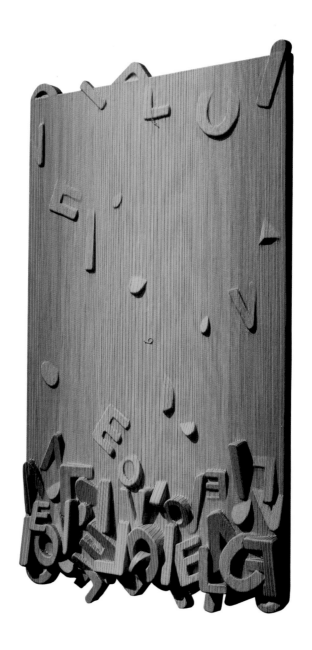

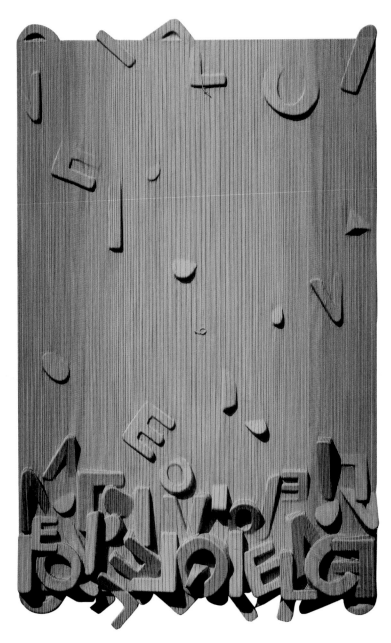

Love Letter21051 82×127cm thread resin on panel 2021

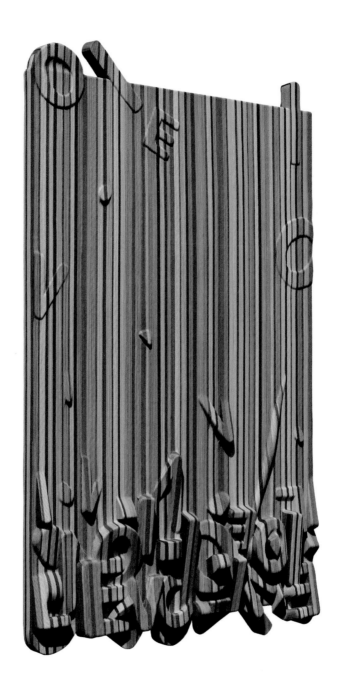

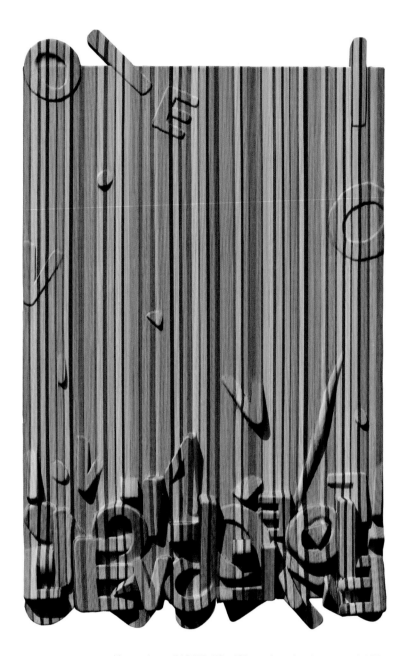

Unsent Letter210413 70×102cm thread resin on panel 2021

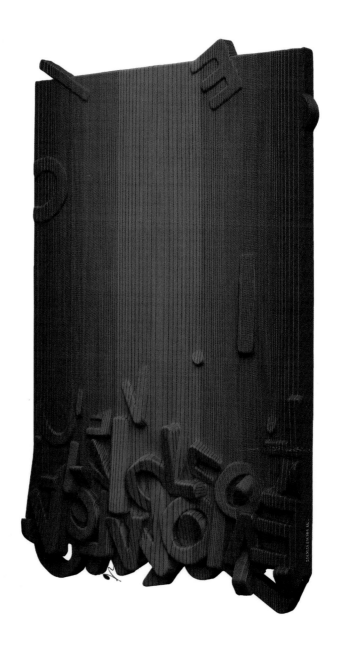

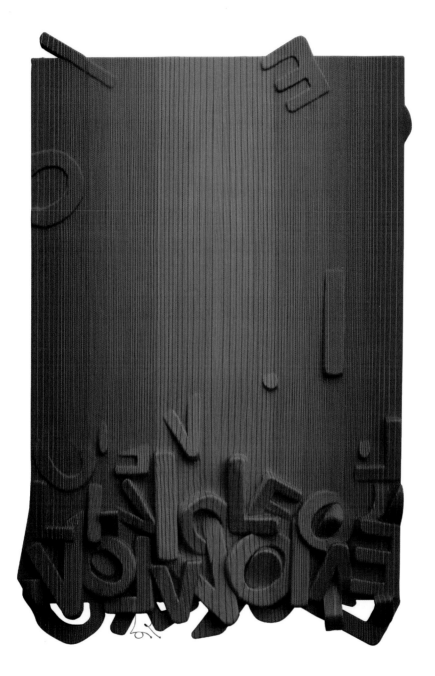

Unsent Letter210515 70×102cm thread resin on panel 2021

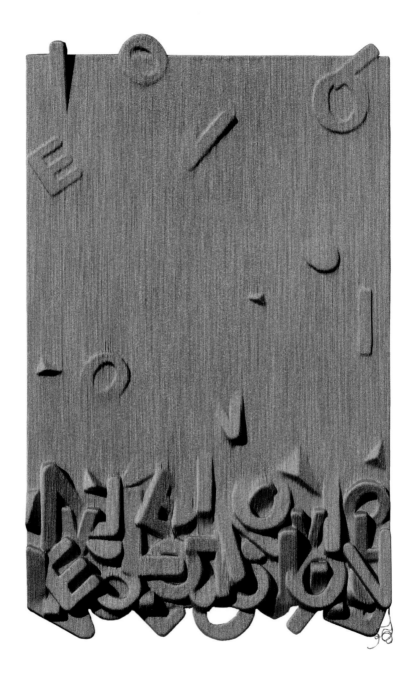

Love Letter22031 82×127cm thread resin on panel 2022

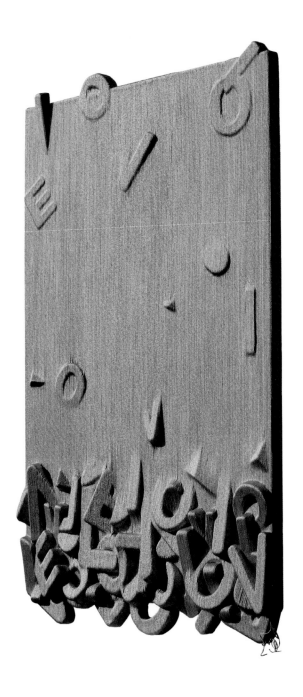

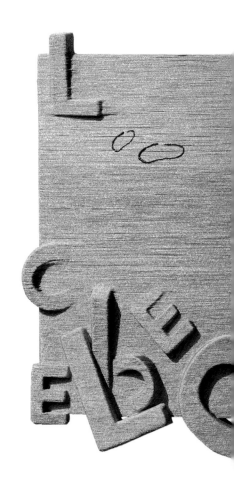

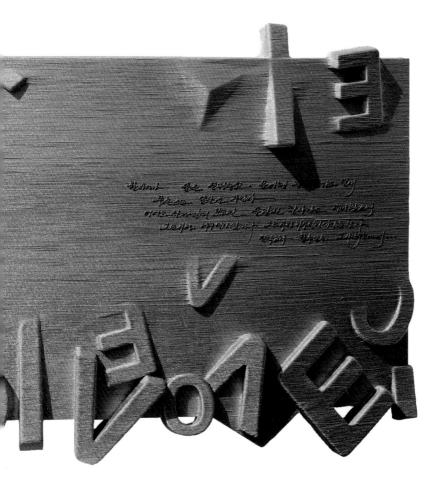

Love Letter22021 95×47cm thread resin on panel 2022

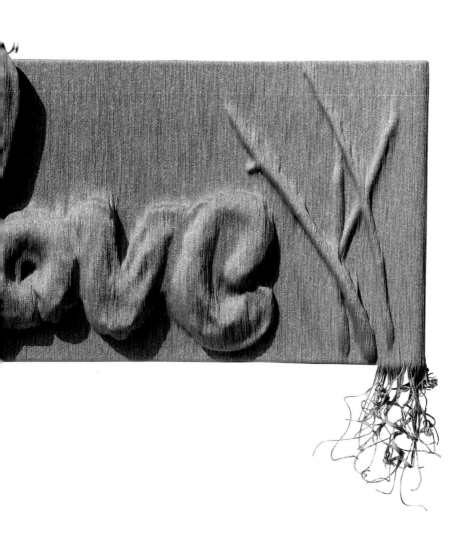

Love Letter220215 61×40 cm thread resin on panel 2022

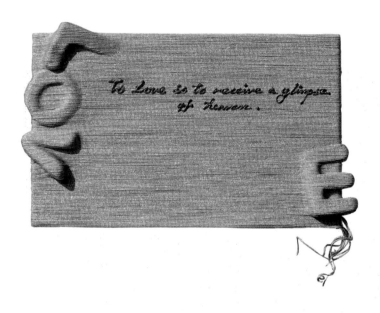

To Love is to receive a glimpse of heaven.

Love22107 27×18cm thread resin on panel 2022
Love22201 30×35cm thread resin on panel 2022

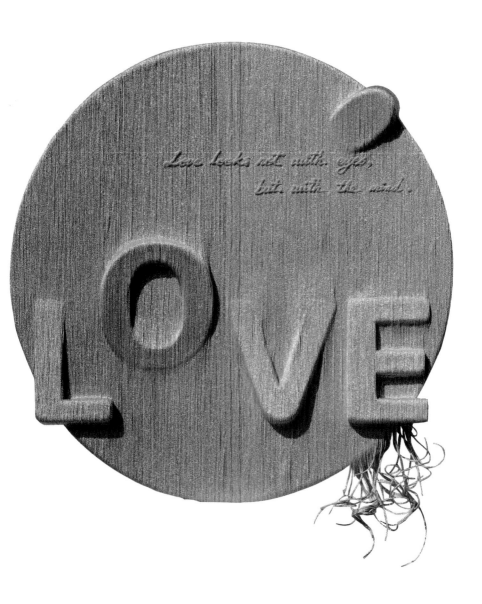

Love looks not with eyes,
but with the mind.

손 일의 "Love Letter"

나의 작품들은 소통에 대한 작가의 사유를 시각화 한다.

사회에서 통용되는 언어를 매체로 소통의 화두를 끊임없이 모색하고 실험하여, 평면조형의 새로운 비젼을 보여 주고자 한다. 간결하고 절제 되어진 색과 반복 되어진 활자, 독창적 재료로 작가의 일관되고 분명한 작품에 대한 이야기를 경험할 수 있을 것이다.

소통에 대한 역사적 고찰과 함께 그 본질적인 작업을 시작하여 기호가 전달되는 인식적인 체계가 아니라 기호가 놓인 위치와 그림자, 작은 움직임에도 느낌을 표현할 수 있는 부조작업과 표면의 물성을 통해 작가만의 섬세한 감성을 전하는 작업을 하고 있다.

실이란 소재는 동양적인 의미에서 타인과의 연결성, 인연, 관계에 대한 해석이며, 입체화된 표면에 한줄 한줄 덮여진 실은 인연을 소중히 이어가는 작가의 의지적 표현이자 단순하지 않은 현대사회의 복잡한 결처럼 개체의 물성이 전체를 화면을 구성 한다.

2022년 봄날에 작업실에서

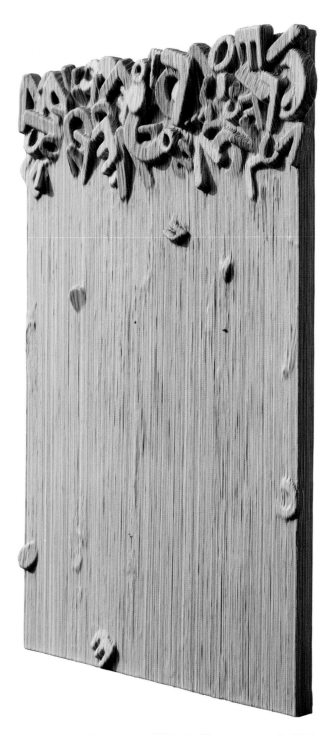

Unsent Letter1962 67×92cm mixed media 2019

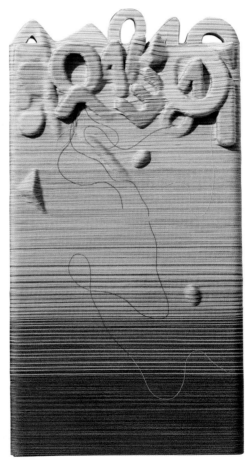

Unsent Letter1996 25×45cm thread resin on panel 2019

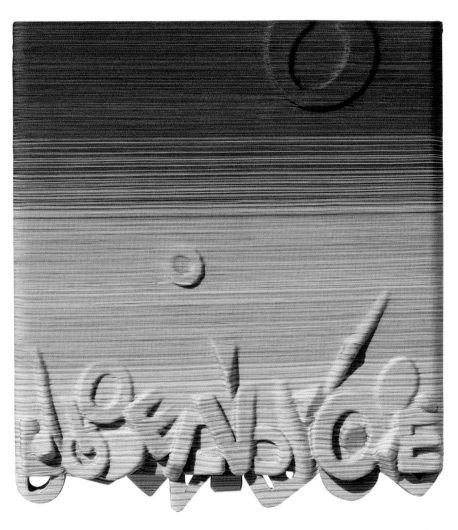

Unsent Letter1997 40×43cm thread resin on panel 2019

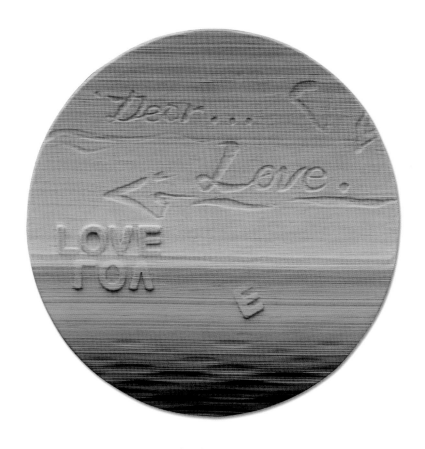

Unsent Letter1982 70×70cm thread resin on panel 2019

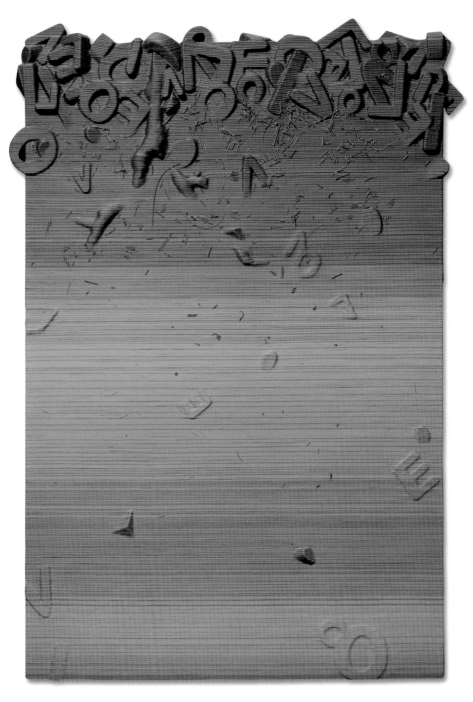

Unsent Letter19107 88×121cm thread resin on panel 2019

Unsent Letter1999 100×34cm thread resin on panel 2019

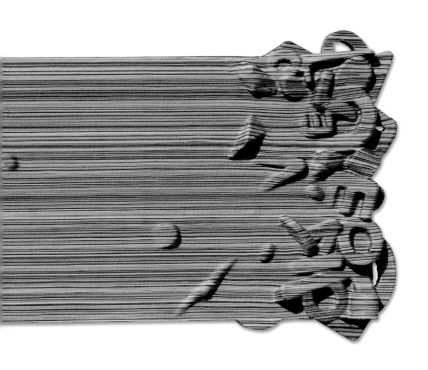

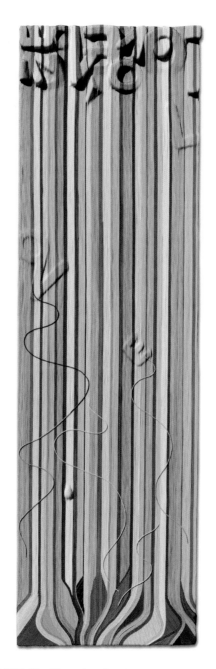

LOVE1955 28×95cm thread resin on panel 2019

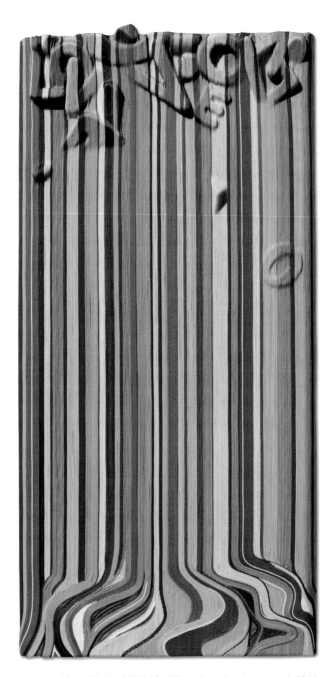

Unsent Letter1995 30×62cm thread resin on panel 2019

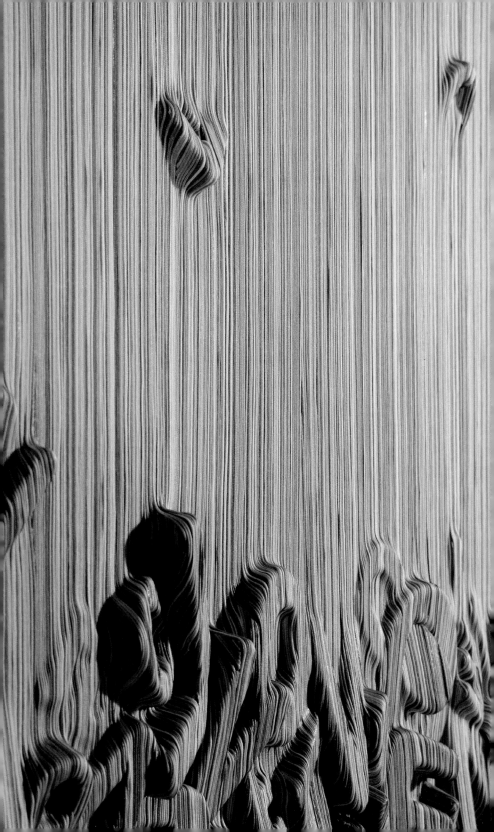

SON IL's "Love Letter"

My works visualize my thoughts on communication as an artist.

They intend to show a new vision of flat modeling by constantly exploring and experimenting with the theme of communication through the medium of language used in the society. You will be able to experience the story of my consistent and clear work with concise and restrained colors, repeated typography, and original materials.

I have produced works delivering a delicate sensibility of my own through the materiality of the surface as well as relief work. They can express feelings even on a location where symbols are placed, their shadows and subtle movement, instead of a sense of cognition where symbols are transferred from one place to another since I conduct historical contemplation on communication and work on the essentiality to resonate.

Starting its essential work with a historical review of communication, it is not a cognitive system in which symbols are transmitted, but through relief work that can express feelings in the location and shadow of symbols, and the physical properties of the surface. Threads as a material are an interpretation of connectivity, relationships, and ties with others in the Oriental sense, and the threads covered on three-dimensional surfaces with each and every strand are to express my will, and the materiality of each object configures the entire pictorial plane just like the complicated layers in the modern society where things are not so simple.

From my studio in spring of 2022

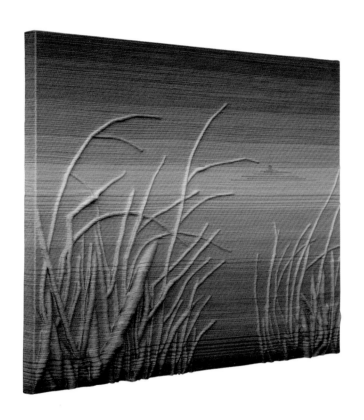

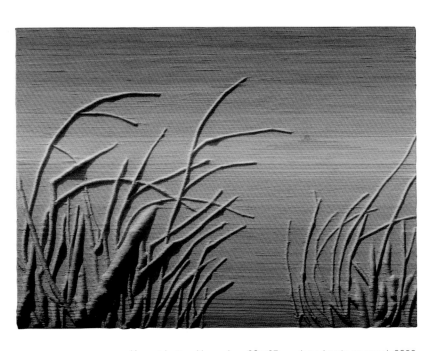

Unsent Letter−November 90×65cm thread resin on panel 2020

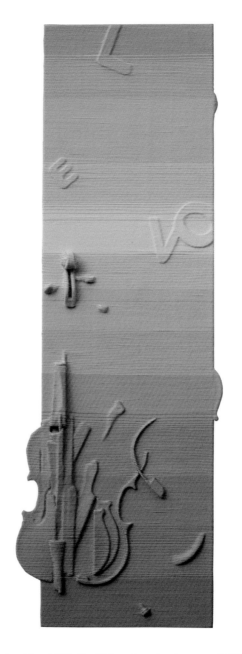

Letter-Muse1967 42×120cm thread resin on panel 2019

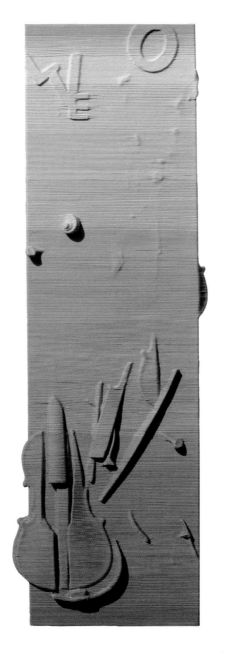

Letter-Muse1968 42×120cm thread resin on panel 2019

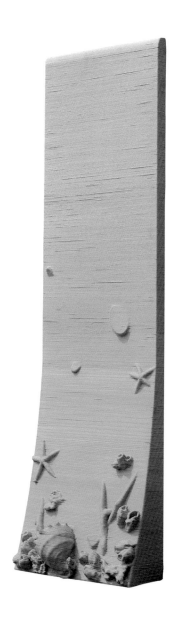

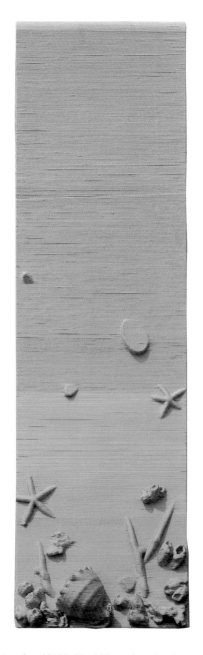

Unsent Letter-Sea 20506　35×123cm　thread resin on panel　2020

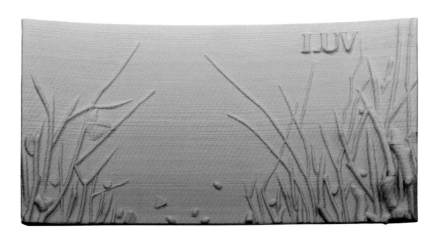

Unsent Letter200812 60×90cm resin wood thread on panel 2020

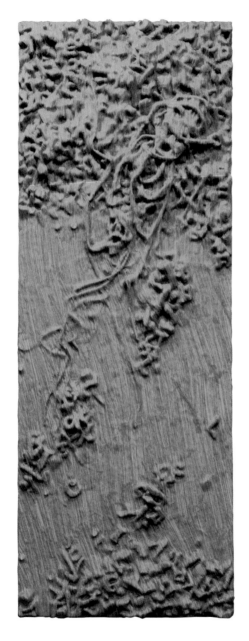

Unsent Letter20717 60×160cm thread resin on panel 2020

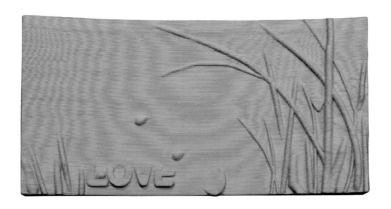

Unsent Letter200811 60×30cm resin wood thread on panel 2020

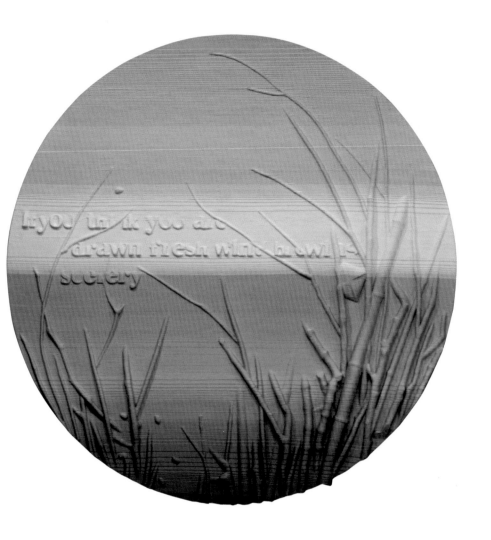

Unsent Letter200810 120×120cm resin wood thread on panel 2020

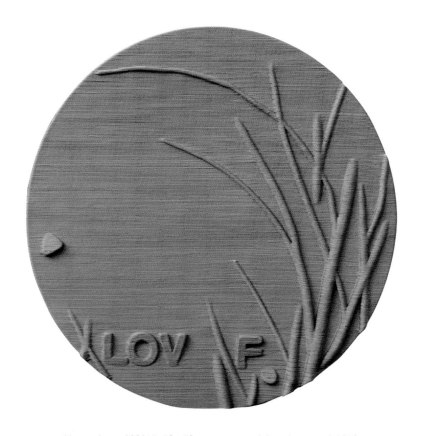

Unsent Letter200815 50×50cm resin wood thread on panel 2020

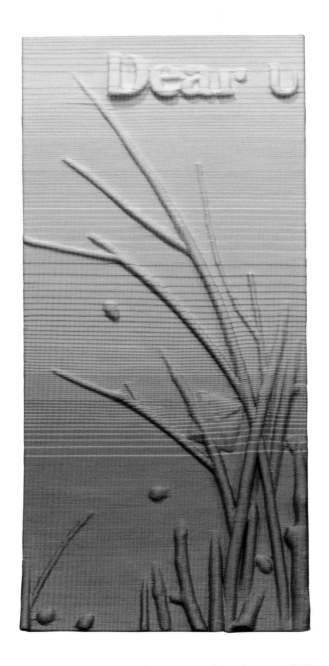

Unsent Letter200813 30×60cm resin wood thread on panel 2020

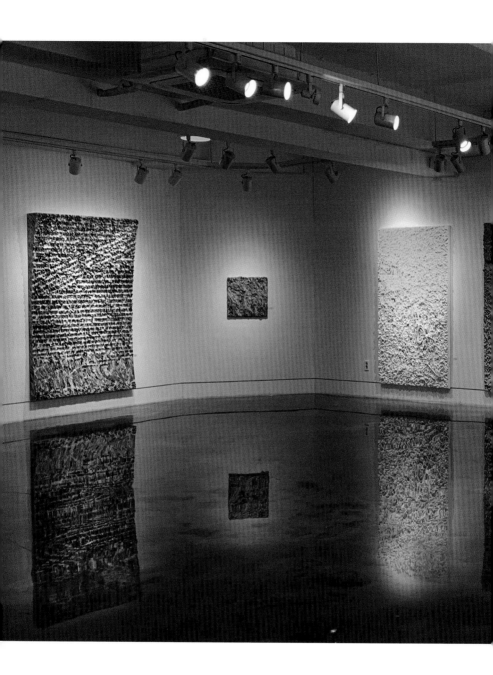

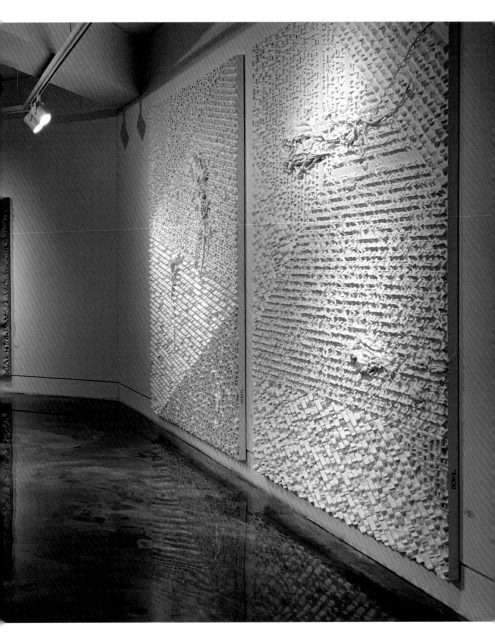

Joy Gallery Busan 2020

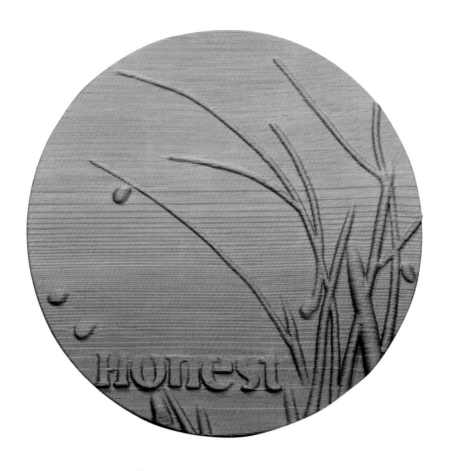

Unsent Letter200814 40×40cm resin wood thread on panel 2020

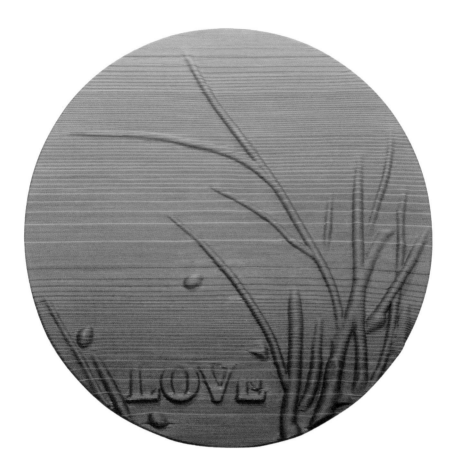

Unsent Letter200813 40×40cm resin wood thread on panel 2020

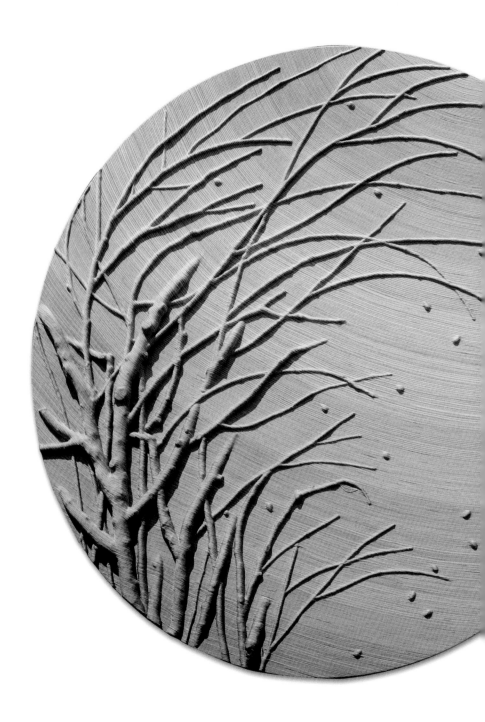

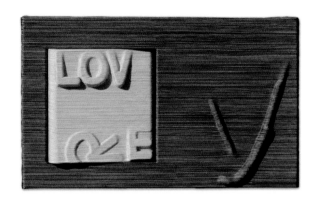

Unsent Letter20301 150×150cm thread resin on panel 2020
Unsent Letter20513 21×38cm thread resin on panel 2020

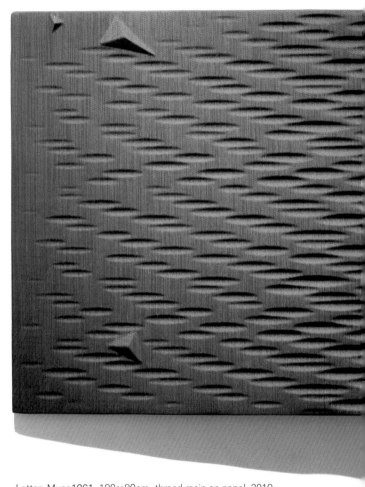

Letter-Muse1961 180×80cm thread resin on panel 2019

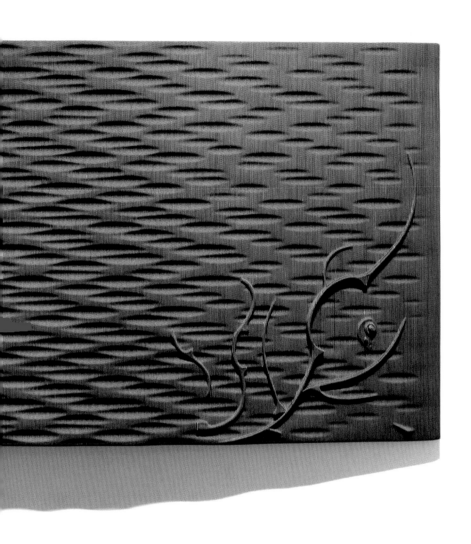

Unsent Letter-Autumn 90×90cm resin wood thread on panel 2020

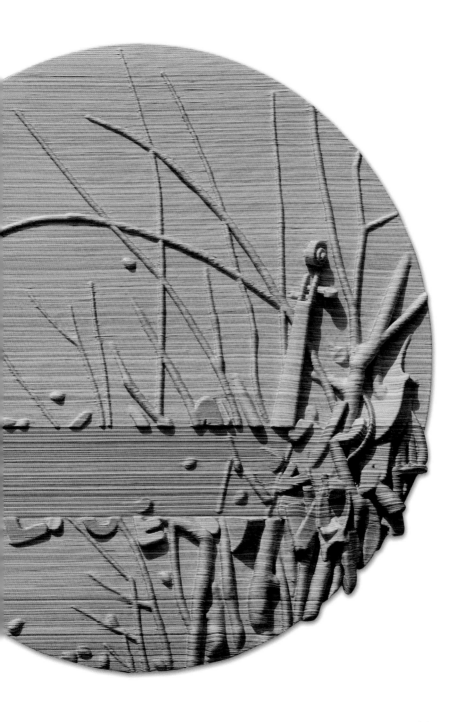

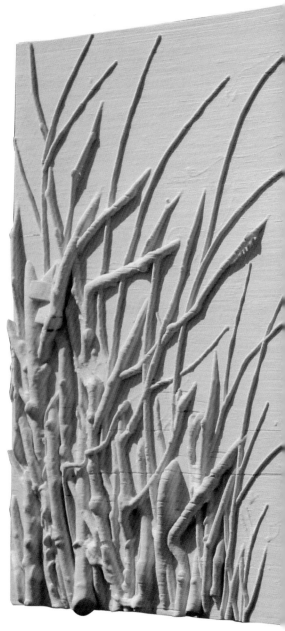

Unsent Letter–Winter
194×112cm resin wood thread on panel 2020

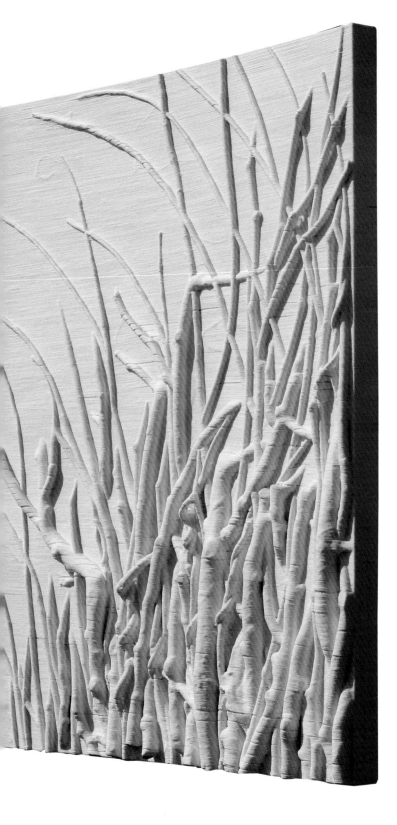

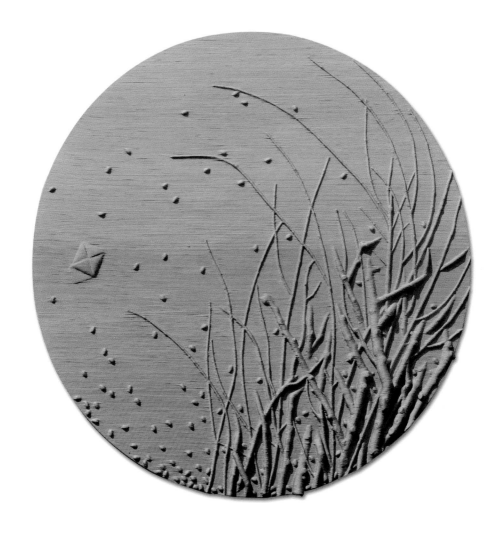

Unsent Letter20302 150×150cm thread resin on panel 2020

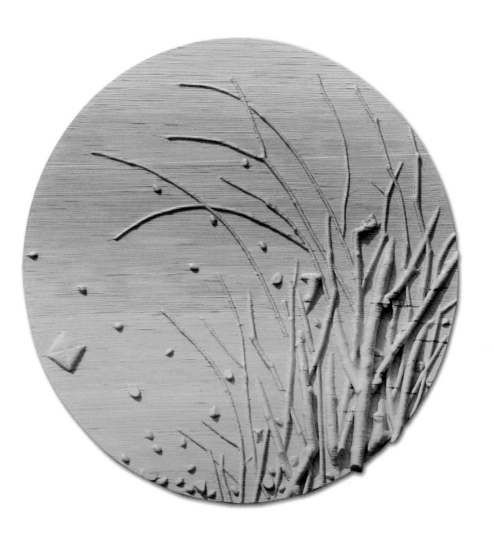

Unsent Letter200315 110×110cm resin wood thread on panel 2020

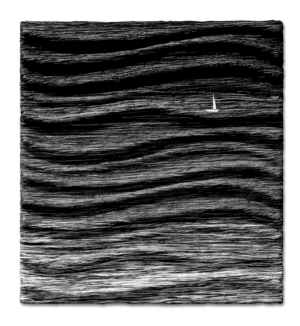

The night sea 191221 50×50cm thread resin on canvas 2019

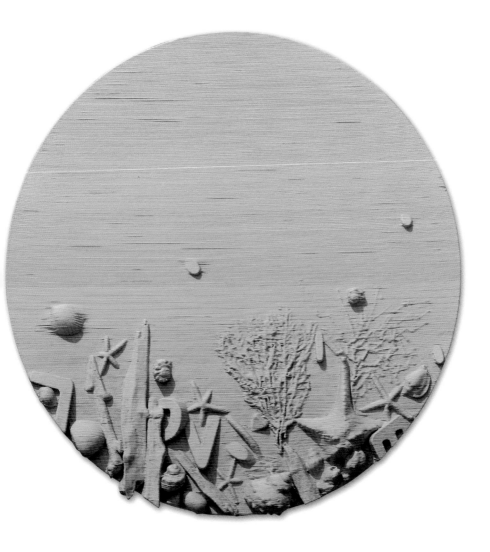

Unsent Letter–Sea 20507 90×90cm thread resin on panel 2020

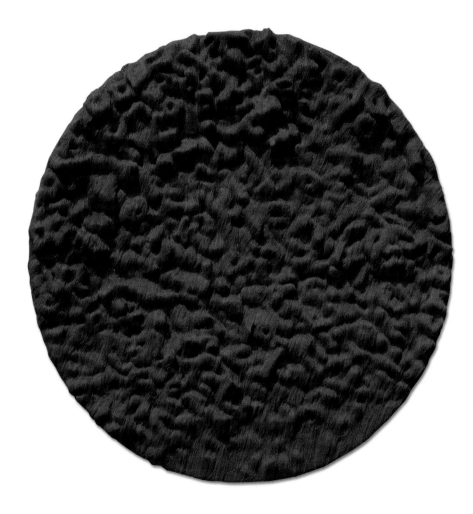

Unsent Letter20611 90×90cm thread resin on panel 2020

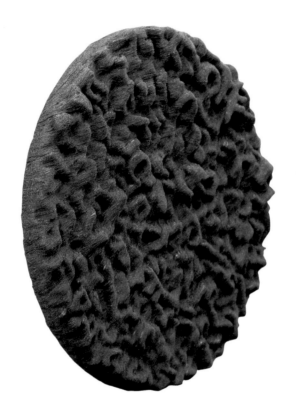

Unsent Letter20611 55×55cm thread resin on panel 2020

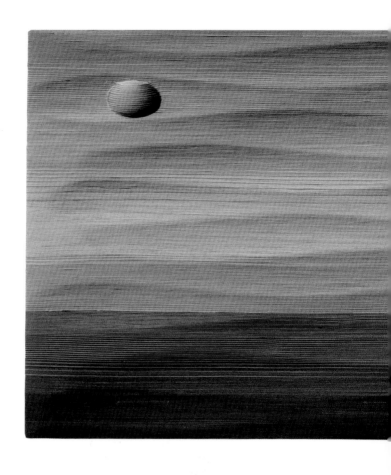

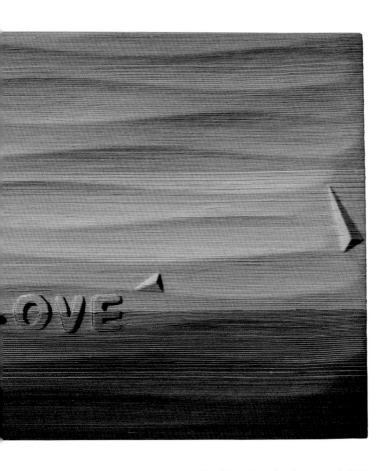

Unsent Letter 1951 120×60cm thread resin on panel 2019

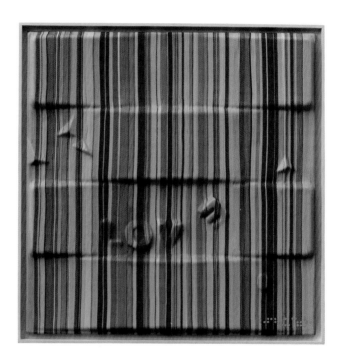

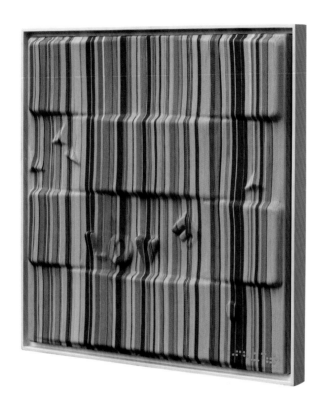

LOVE1908 50×50cm thread resin on canvas 2019

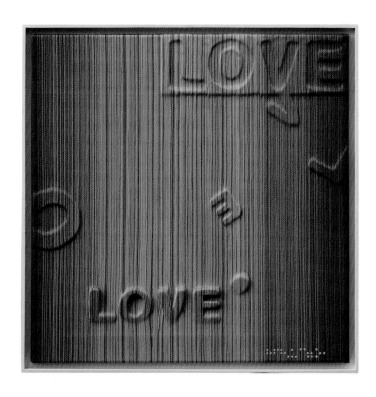

LOVE1909 50×50cm thread resin on canvas 2019

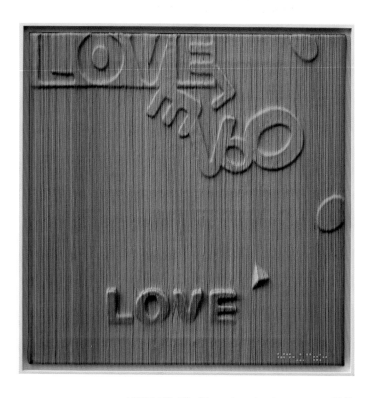

LOVE1909 50×50cm thread resin on canvas 2019

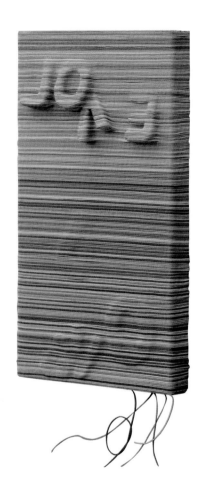

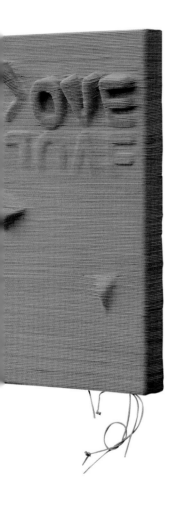
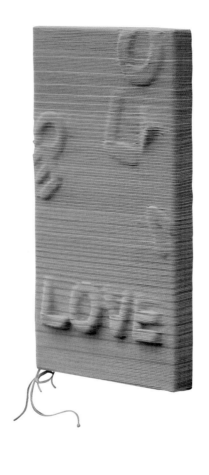

Love21091 15×29cm thread resin on panel 2021
Love21093 15×29cm thread resin on panel 2021
Love21092 15×29cm thread resin on panel 2021

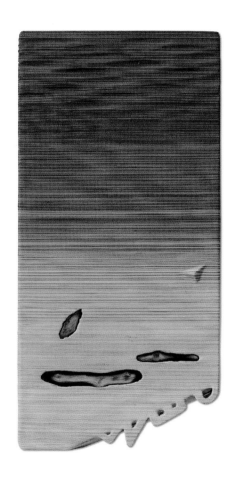

Unsent Letter1982　40×80cm　thread resin on panel　2019

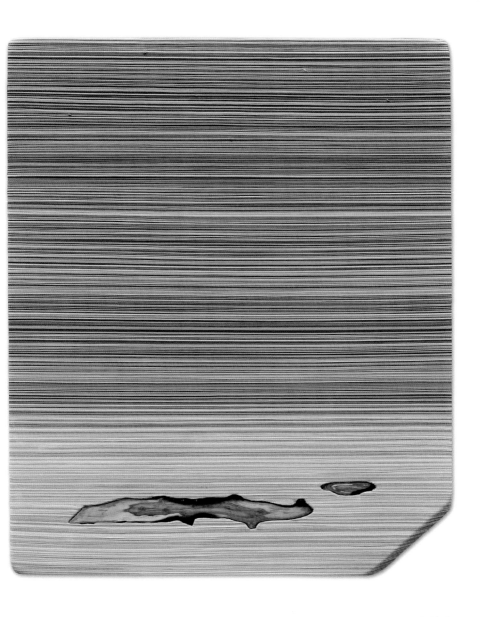

Unsent Letter1965 120×130cm thread resin on panel 2019

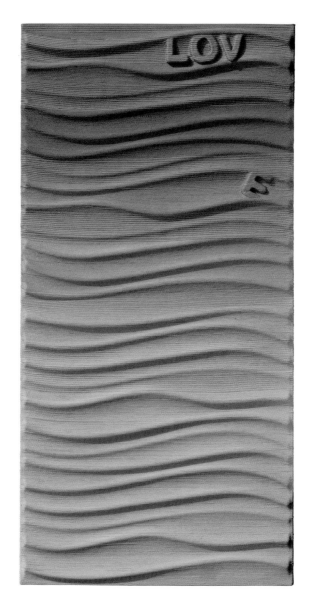

Unsent Letter 1902 50×100cm thread resin on panel 2019

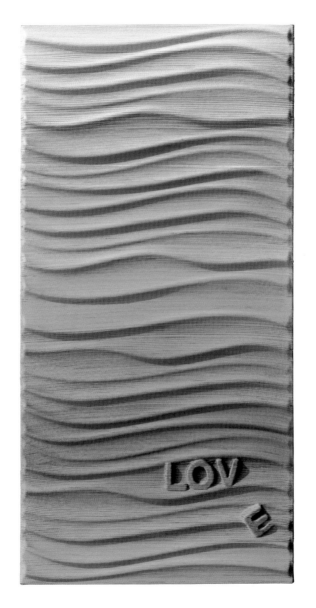

Unsent Letter 1901 50×100cm thread resin on panel 2019

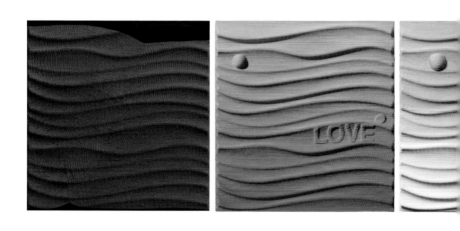

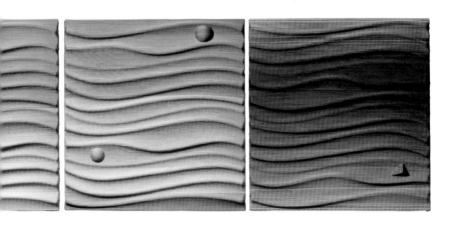

WAVE1903　50×50cm　thread resin on canvas　2018
LOVE1912　50×50cm　thread resin on canvas　2019
WAVE1905　50×50cm　thread resin on canvas　2018
WAVE1903　50×50cm　thread resin on canvas　2018
WAVE1904　50×50cm　thread resin on canvas　2018

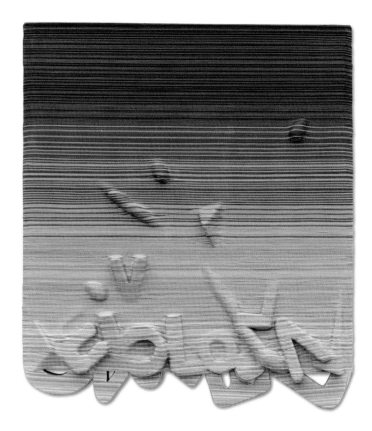

Unsent Letter1981 40×44cm thread resin on panel 2019

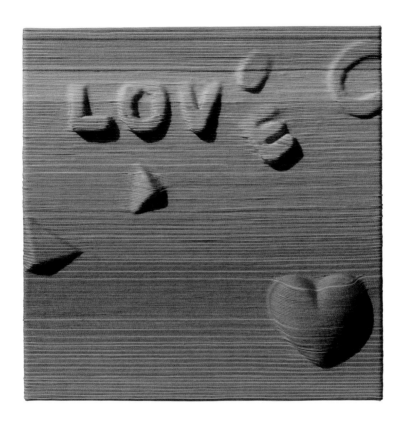

Love1932 25×25cm thread resin on panel 2019

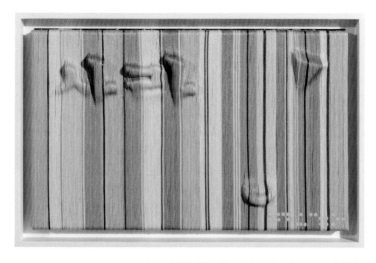

Love1957 25×15cm thread resin on panel 2019

Love1950　12×22×6cm　thread resin　2019

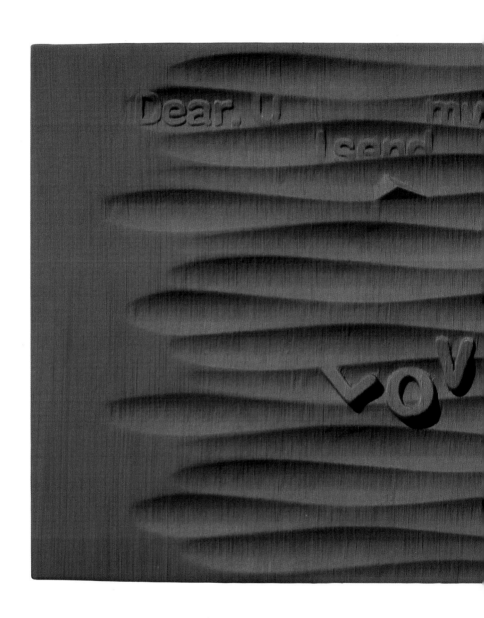

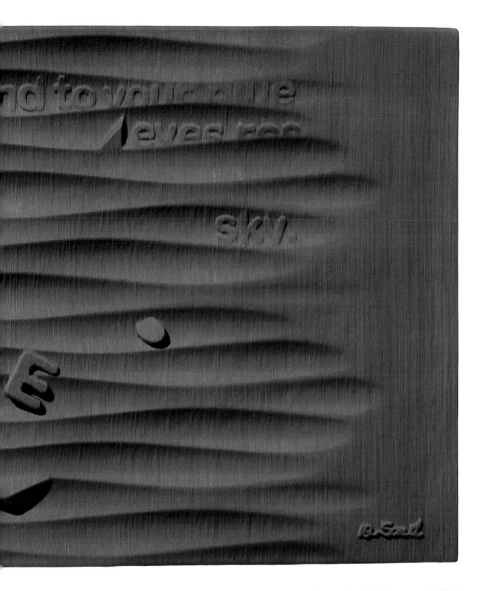

Unsent Letter1911 152×80cm thread resin on panel 2019

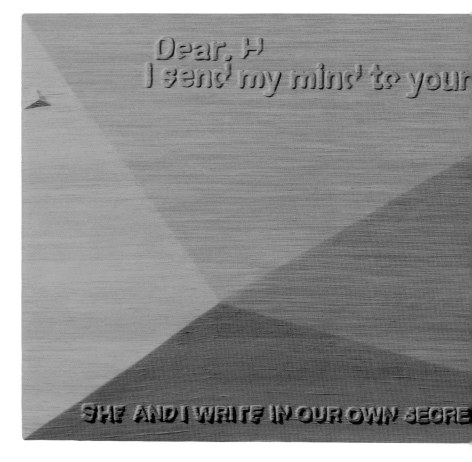

Unsent Letter1912 150×90cm thread resin on panel 2019

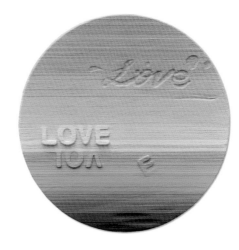

Unsent Letter1983 60×60cm thread resin on panel 2019

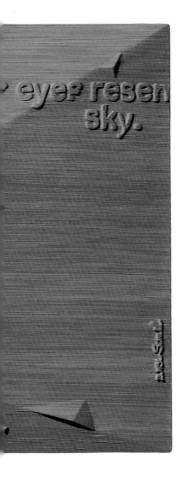

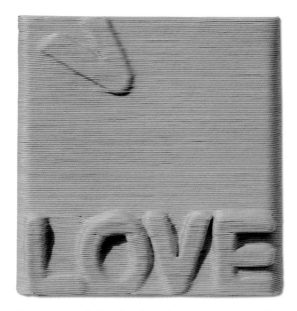

Unsent Letter19101 16×16cm thread resin on panel 2019

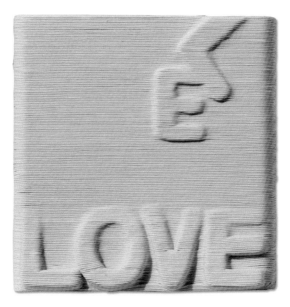

Unsent Letter19102 16×16cm thread resin on panel 2019

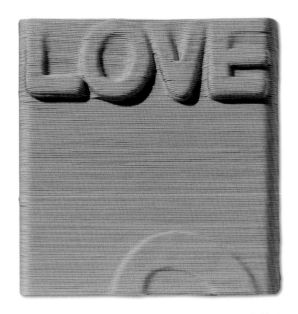

Unsent Letter19103 16×16cm thread resin on panel 2019

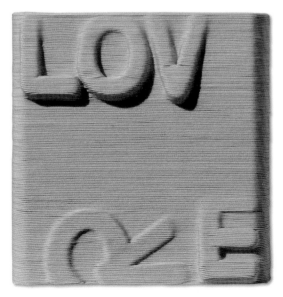

Unsent Letter19103 16×16cm thread resin on panel 2019

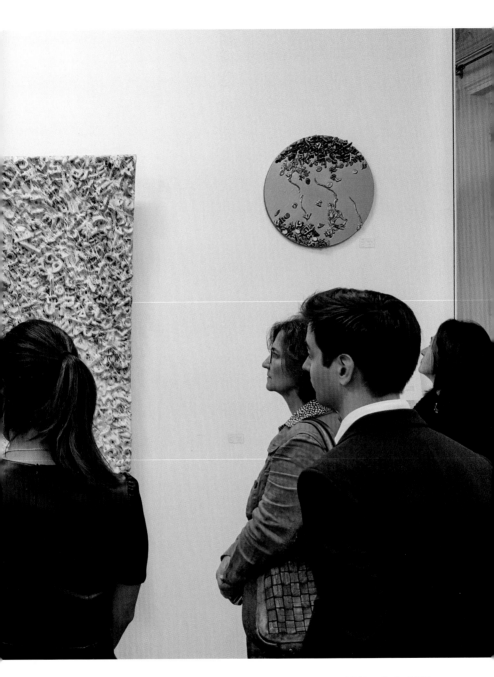

Solo invitation exhibition Paris 2017

손 일

개인전
2020 개인 초대전 조이 갤러리 외 28회 (파리/뉴욕/서울/북경/부산)

주요 전시
2019 VENICE Art Biennale (Venice, Palazzo Bembo)
2018 ART MIAMI CONTEXT (U.S.A, Miami)
2017~2009 KIAF Korea International Art Fair (Seoul, COEX)
2017~2014 ARTBUSAN (Busan, Bexco)
2016 L.A Art Show (U.S.A, L.A)
2015~2014 Art Stage Singapore (Singapore, Marina Bay Sands)
2015~2012 Art Paris Art Fair (France, Grand Palais)
2014 VIENNA Fair (Austria, Messe Wien)
2014~2012 Scope MIAMI (U.S.A, Miami)
2013 Scope Basel (Switzerland, Basel)
2013~2009 SOAF Seoul Open Art Fair (Seoul, COEX)

수상
2009~1999 대한민국미술대전 통합 '대상' 및 '특선' 3회 / 한국미술협회
2009 오늘의 작가상 수상 / 부산미술협회
2000~1996 부산미술대전 통합 '대상' 및 '특선' 4회 / 부산미술협회

주요 작품 소장처
프랑스 국립 인류사박물관 /국회의사당 / 국립현대미술관 / 경남도립미술관
부산광역시청 / 해외문화홍보원 /부산고등법원 / 부산일보사 / 부산체신청

주 소 경남 밀양시 산내로 356-10
전 화 010-3832-8727
E-mail: ssiart89@naver.com

SON IL

Solo Exhibition

2020 Solo invitation exhibition Gallery JOY Busan, Korea and 28th
 (Paris / New York / Seoul / Beijing / Busan)

Main Exhibition

2019 VENICE Art Biennale (Venice,Palazzo Bembo)

2018 ART MIAMI CONTEXT (U.S.A, Miami)

2017-2009 KIAF Korea International Art Fair (Seoul, COEX)

2017-2014 ARTBUSAN (Busan, Bexco)

2016 L.A Art Show (U.S.A, L.A)

2015-2014 Art Stage Singapore (Singapore, Marina Bay Sands)

2015-2012 Art Paris Art Fair (France, Grand Palais)

2014 VIENNA Fair (Austria, Messe Wien)

2014-2012 Scope MIAMI (U.S.A, Miami)

2014 Scope Basel (Switzerland, Basel)

2013-2009 SOAF Seoul Open Art Fair (Seoul, COEX)

Awards

2009 '1st Prize' and three selections, Korea Art Competition /
 Korea Art Association

2009 'Today's Artist / Busan Art Association

2000 '1st Prize' and four selections, Busan Art Competition /
 Busan Art Association

1997 'Best Prize' Buil Art Competition / Busan Ilbo

Collections

Musee de l'Homme Paris / The National Assembly of Korea

Museum of Contemporary Art, Korea / Gyeongnam Provincial Museum of Art Busan City Hall

Korea Culture & Information Service

Busan High Court / Dong-A University / Busan Ilbo / Busan Office of Postal Service

Address: 356-10 Sannae-ro Miryang-si Gyeongnam

Mobile +82-10-3832-8727

E-mail ssiart89@naver.com